This book belongs to:

DOODLING FOR
CAT PEOPLE

by Gemma Correll

Brimming with creative inspiration, how-to projects, and useful information to enrich your everyday life, Quarto Knows is a favorite destination for those pursuing their interests and passions. Visit our site and dig deeper with our books into your area of interest: Quarto Creates, Quarto Cooks, Quarto Homes, Quarto Lives, Quarto Drives, Quarto Explores, Quarto Gifts, or Quarto Kids.

Inspiring | Educating | Creating | Entertaining

© 2015 Quarto Publishing Group USA Inc.

Artwork and font © 2015 Gemma Correll
Illustrated and written by Gemma Correll
Select text by Stephanie Carbajal

First published in 2015 by Walter Foster Publishing,
an imprint of The Quarto Group,
6 Orchard Road, Suite 100, Lake Forest, CA 92630, USA.
T (949) 380-7510 F (949) 380-7575 www.QuartoKnows.com

Walter Foster Publishing titles are also available at discount for retail, wholesale, promotional, and bulk purchase. For details, contact the Special Sales Manager by email at specialsales@quarto.com or by mail at The Quarto Group, Attn: Special Sales Manager, 401 Second Avenue North, Suite 310, Minneapolis, MN 55401, USA.

ISBN: 978-1-60058-457-2

Printed in China

14

TABLE OF CONTENTS

How to Use This Book 4
20 Signs You're a Cat Person 6
Doodled Cats. .10
Doodled Cat Faces 16
Expressions . 19
Anthropomorphic Cats24
Fashionable Furballs 30
Draw a Kitty .36
Draw a Cozy Curled-Up Kitty 40
Draw a Kitty Sitting Pretty44
Make a Doodled Cat Mug48
What's in a Name?54
Cats Doing Tricks56
A Day in the Life 60
Kitty Kingdoms. 62
Cats & Dogs. .66
Draw a Perky, Fluffy Persian 72
Draw a Str-e-e-etching Kitty76
Draw a Super Sphynx 80
Cattitude .84
Draw an Anthropomorphic Cat 88
Cats in Hats . 92
Cat-Toids . 94
Funky Fur .96
Food! . 106
Playtime! . 108
Cats in Motion.112
Kitties on Vacation 116
Doodle Diary. 122
About the Illustrator 128

HOW TO USE THIS BOOK

This book is just a guide. Each artist
has his or her own style. Using your imagination
will make the drawings more unique and special!
The fun of doodling comes from not trying too hard.
So don't worry about making mistakes or trying
to achieve perfection.

Here are some tips to help you get the
most of this doodling book.

DOODLE PROMPTS

The prompts in this book are designed to get your creative juices
flowing—and your pen and pencil moving! Don't think too much about
the prompts; just start drawing and see where your imagination takes
you. There's no such thing as a mistake in doodling!

STEP-BY-STEP EXERCISES

Following the step-by-step exercises is fun and easy! The red lines
show you the next step. The black lines are the steps you've already
completed.

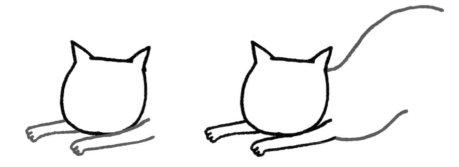

SUPPLIES

Doodling doesn't require any special tools or materials. You can draw with anything you like! Here are a few of my favorite drawing tools.

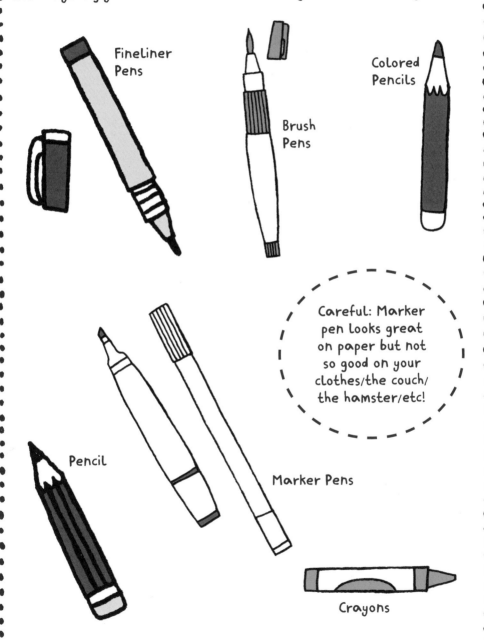

Fineliner Pens

Brush Pens

Colored Pencils

Careful: Marker pen looks great on paper but not so good on your clothes/the couch/ the hamster/etc!

Pencil

Marker Pens

Crayons

20 SIGNS YOU'RE A CAT PERSON

1. You celebrate your cat's birthday.

2. Your phone is full of photos of your cat—not your friends and loved ones.

3. You have been known to call your cats "my children."

4. You are perpetually covered in cat fur.

5. You send holiday cards cosigned (with a paw print, of course!) by your cat.

6. You eat budget tuna, while your pampered cat feasts on deluxe, organic salmon.

7. You keep all of your cardboard boxes for kitty to play in.

8. You have a gold card at the pet store.

9. Your entire living room is occupied by a giant cat tree.

10. Your pockets are full of kitty treats.

11. You talk to your cats when nobody else is around.

12. You talk to your cats when other people are around...you just don't care.

13. Your cat has her own website and Facebook page.

14. Your email address is catperson@ilovecats.com.

15. Your shelves are full of cat ornaments, books about cats, photos of cats, and random cat toys.

16. At any given moment, you know that there are at least 11 cat toys under the couch.

17. Cat hair in your food is just extra fiber, right?

18. You'd rather spend a night on the couch with your cats than go out on the town.

19. You're not actually sure how many cats you own, but it's at least five.

20. You're not a "Crazy Cat Person"—You're a "Feline Enthusiast."

DRAW OR PASTE A PICTURE OF YOUR CAT IN THE FRAME.

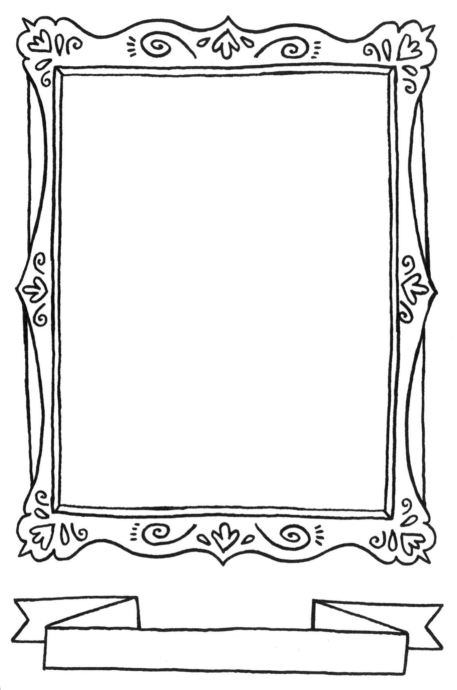

My Cat

Favorite game:

Favorite place to sleep:

Favorite toy:

Favorite snack or treat:

Favorite way to be naughty:

DOODLED CATS

Cats come in all different varieties—
some have long hair, some have short hair,
and some have no tails!

Shorthair Cats

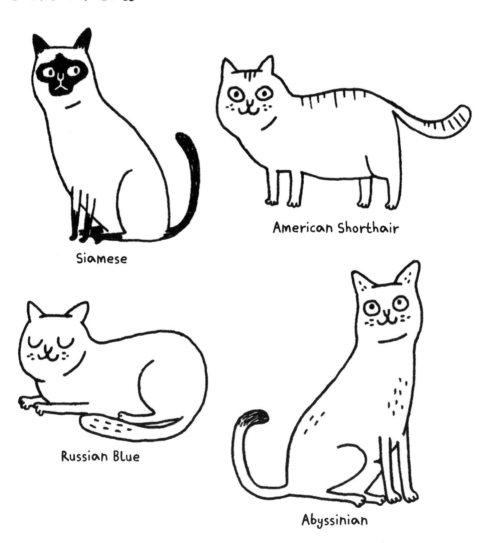

Siamese

American Shorthair

Russian Blue

Abyssinian

Longhair Cats

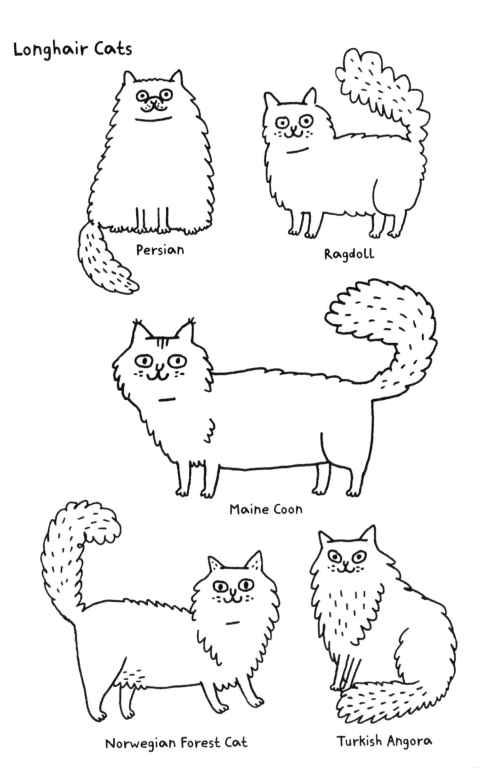

Persian

Ragdoll

Maine Coon

Norwegian Forest Cat

Turkish Angora

Unusual Cats

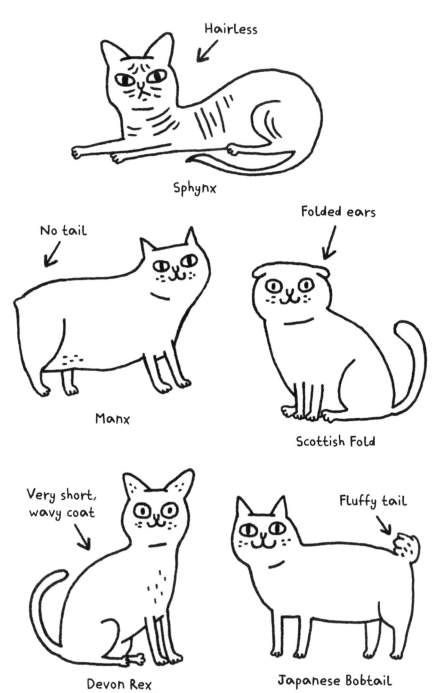

Hairless

Sphynx

No tail

Manx

Folded ears

Scottish Fold

Very short, wavy coat

Devon Rex

Fluffy tail

Japanese Bobtail

What are your favorite kinds of cats?
Doodle them here.

14

DOODLED CAT FACES

Some cats have long faces.
Others have round or square faces.

Some cats have big ears.
Some cats have little ears, or even folded ears.

Some cats are very fluffy.

Some cats have squishy noses.

Cats have all sorts of different facial markings.

Some cats have very simple markings.

Some cats have unusual markings.

Some cats have mustaches!

EXPRESSIONS

Cats make all kinds of expressions, and they're not shy about letting you know how they feel! Below are some common feline facial expressions.

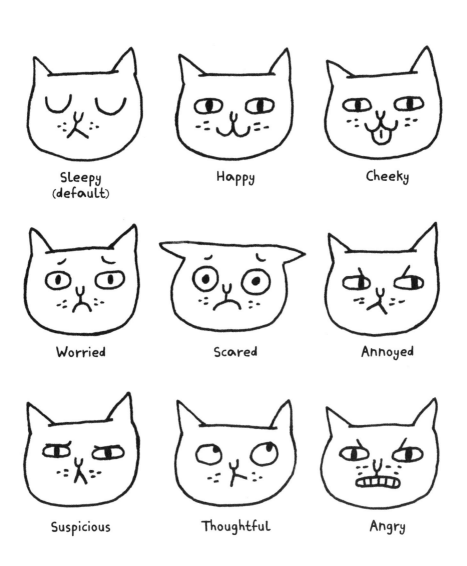

Sleepy
(default)

Happy

Cheeky

Worried

Scared

Annoyed

Suspicious

Thoughtful

Angry

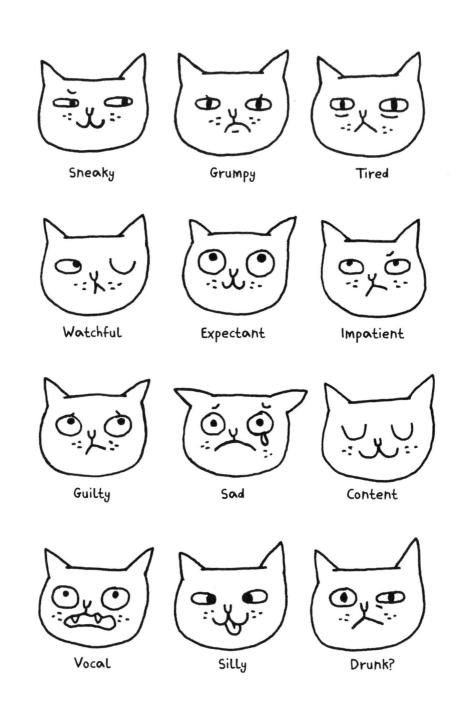

Sneaky Grumpy Tired

Watchful Expectant Impatient

Guilty Sad Content

Vocal Silly Drunk?

Use this page to practice drawing different facial expressions.

Cats' tails are very expressive. Here are a few different tail-spressions!

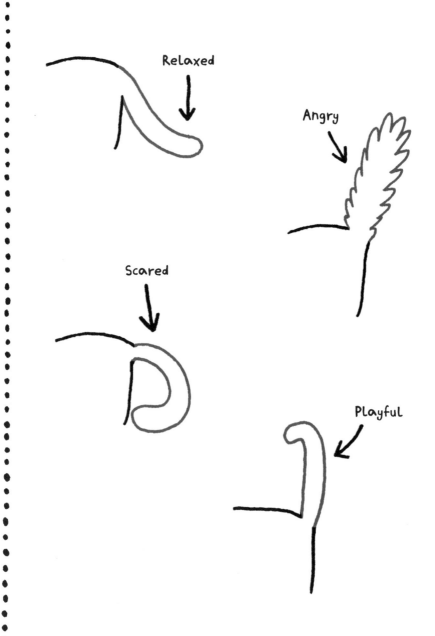

Relaxed

Angry

Scared

Playful

What kind of mood is your kitty usually in?
Doodle it here!

ANTHROPOMORPHIC CATS

Cats don't work. Humans work to buy things
for cats—that's just the way it is.
But imagine if cats did have jobs...

These cats have been anthropomorphized
(that's fancy talk for "attributing human
characteristics to animals"). To draw an
anthropomorphic cat, just imagine you're drawing
a person, but with a cat's head, tail, and paws.

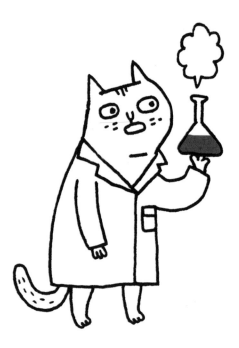

Stinky the Scientist

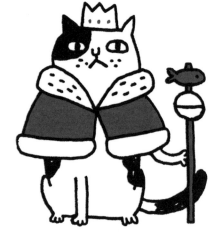

King Jingles McSnuggleton IV

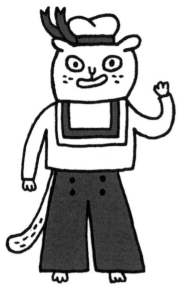

Scooter the Sailor

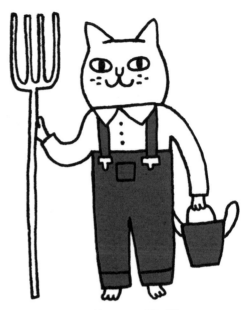

Farmer Fluffy

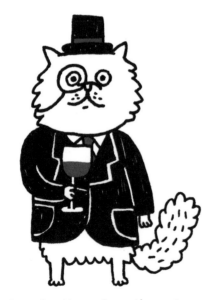

Sir Sebastian of Southampton

Chocolate mouse!

Casper the Chef

Super Smudge

Doctor Dusty DiMaggio

Whiskers the Waiter

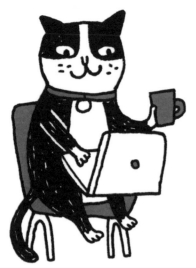

Blochie the Blogger

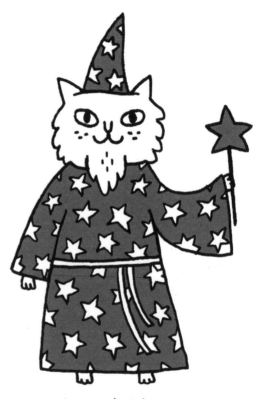

Wiggles the Wizard

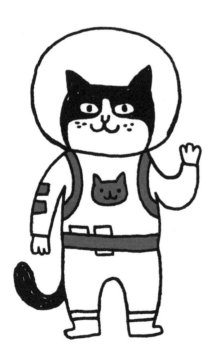

Fluffykins the Astronaut

If your cat had a profession (other than "Lord over All Things"), what would it be? Doodle your ideas here.

FASHIONABLE FURBALLS

The Homebody

The Adventurer

The Sporty

The Smarty Pants

The Exercise Fanatic

The Sun Worshipper

The Joker

The Cool Guy

The Snuggler

The Punk

The Retro Chick

Design some fabulous outfits for these kitties.

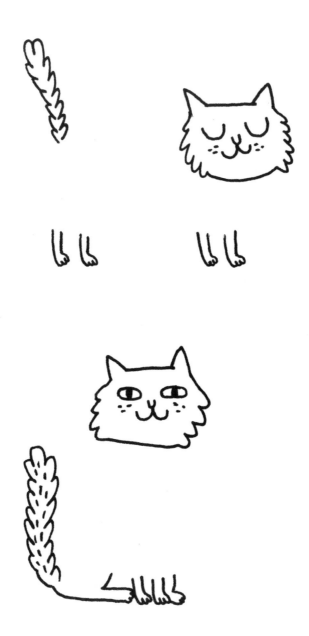

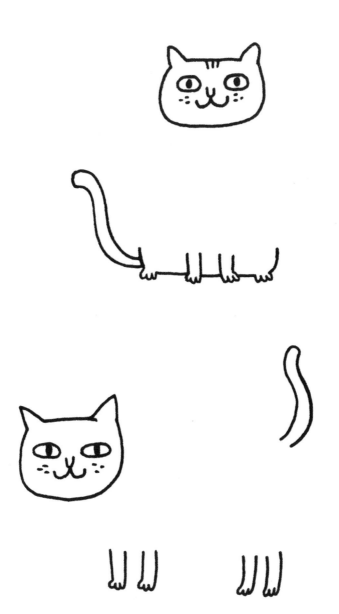

DRAW A KITTY

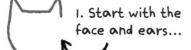 1. Start with the face and ears...

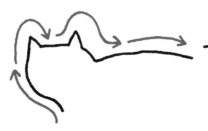 Draw in this direction. Try and do it in one continuous line.

2. Next add the tail...

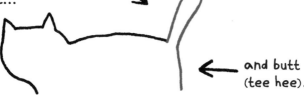 and butt (tee hee).

3. Give the poor cat some legs already!

 Don't forget the tiny kitty toes. Aww!

 Follow the same basic outline but make your line squiggly for a fluffy cat.

4. Let's draw the face now. Try out some different expressions.

5. Add some essential details.

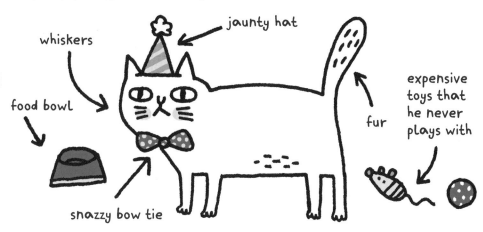

whiskers

jaunty hat

food bowl

snazzy bow tie

fur

expensive toys that he never plays with

Doodle your kitty here!

↓

DRAW A COZY CURLED-UP KITTY

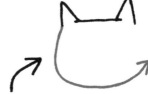

1. Start by drawing the ears.

2. Then draw a curve for the head.
Stop at the bottom right corner.

3. Continue the curve from the neck in a semicircle.

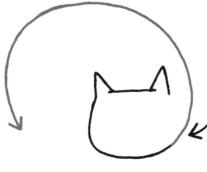

4. Now add the tail,
tucking it under the chin.

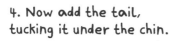

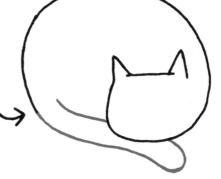

5. Add a little curve to show the back thigh.

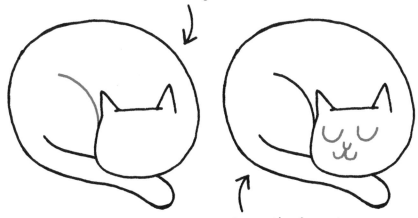

6. Draw the face: two semicircles for the closed eyes, a nose, and a mouth.

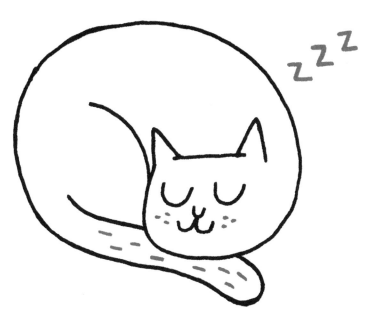

7. Lastly, add any small details that you like— whiskers, fur, stripes, etc.

Doodle your curled-up kitty here!

↓

DRAW A KITTY SITTING PRETTY

1. Draw the head first.

2. Next draw a straight (ish!) Line for the front

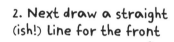

...and a curved Line for the back.

3. Add paws and the other front Leg.

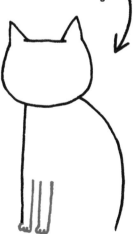

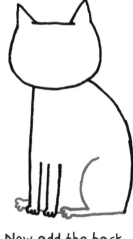

4. Now add the back Legs and paws and fill in any gaps.

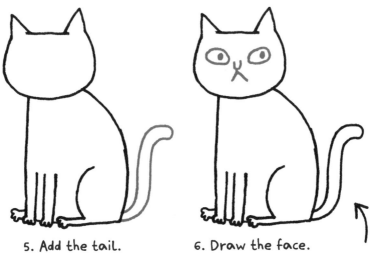

5. Add the tail.

6. Draw the face.
Try different expressions!

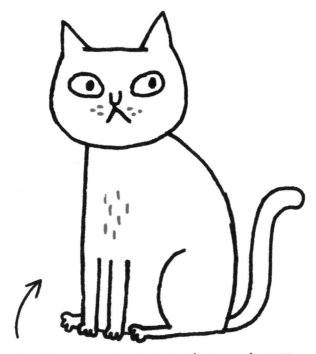

7. Doodle any extra details that you feel like adding...and you're finished!

Doodle your pretty kitty here!

↓

MAKE A DOODLED CAT MUG

Here's what you'll need:

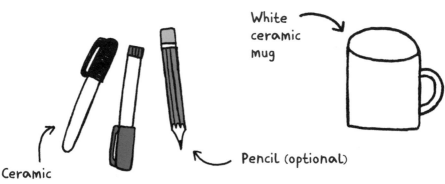

White ceramic mug

Pencil (optional)

Ceramic paint pens or permanent markers (any colors)

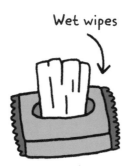

Wet wipes

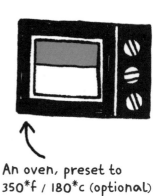

An oven, preset to 350*f / 180*c (optional)

1. Decide what you're going to draw on the mug.

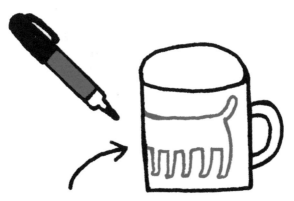

I'm going to draw a
cat with lots of legs
because...well, why not?

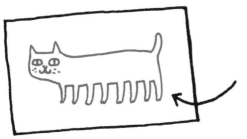

2. Draw your design out
on paper first.

You can also pencil the
design out on the mug if
you feel like it.

3. Start drawing
your design on
the mug.

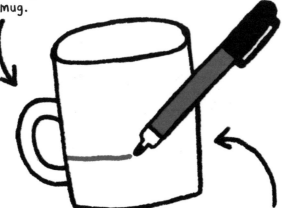

Start on the opposite side to your
drawing hand so that you don't
smudge your artwork as you go
around the mug.

Don't worry if you make a mistake—just
wipe it clean with a wet wipe while the
paint is still wet. (Make sure it's dry
before you continue drawing.)

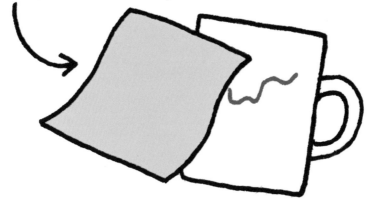

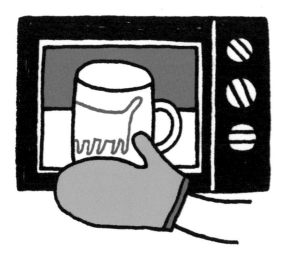

4. If you used paint pens, you can make your mug dishwasher safe by baking it in the oven for 45 minutes at 350*f / 180*c (or whatever your paint-pen packaging tells you to do).

While you wait, eat some cookies. You deserve it.

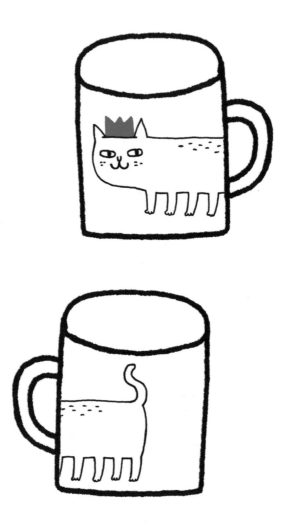

5. Ta da! Let your mug cool, and you're ready to start sipping in style.

ARTIST TIP

You can also draw on other ceramics. Try...

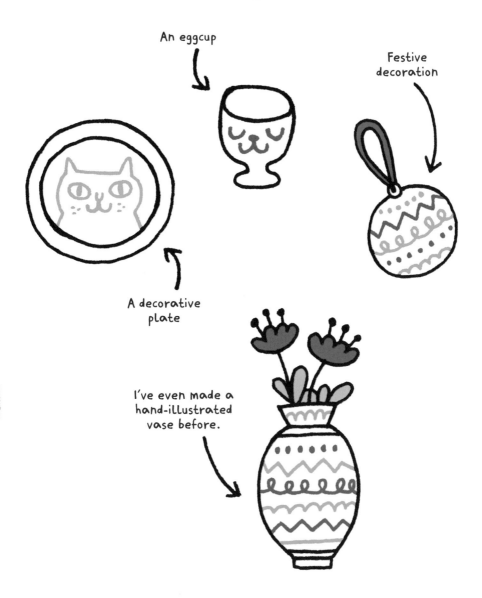

An eggcup

Festive decoration

A decorative plate

I've even made a hand-illustrated vase before.

Please note: Ceramics decorated with permanent markers are not dishwasher safe. Do not immerse in hot water or scrub.

WHAT'S IN A NAME

Stumped on what to name your next furry friend? Check out these suggestions for inspiration. Then add your own ideas to the list!

Hubris (hyoo—bris)
noun: a great or foolish amount of pride or confidence

Gouda
Mmmm, cheese...

Gatsby
This one's for all you literary mavens

Nutmeg
After your favorite spice

Houdini
For the cleverest of cats

Armani
For the fashion lover

Your Majesty
No explanation needed

Chianti
Because what more do you need on a Friday night?

Egypt
To pay homage to your feline's ancestral roots

Sir Naps—a—lot
Because...well...you know

Add your ideas here!

↳

CATS DOING TRICKS

Unlike their canine counterparts, cats can be difficult to train. This isn't because they can't perform. They simply won't. Go ahead and try it.

Imagine if you could train your kitty to perform fantastic feats... What kinds of things would they do? Doodle your ideas here.

A DAY IN THE LIFE

Eating, sleeping, and ruling the world...our spoiled
fur babies are truly livin' the life.

7:30 AM Yowl repeatedly outside Human's door until
 Human gets out of bed

8 AM Breakfast—scatter a few pieces of food
 on the floor to save for later

10 AM Nap on the sofa...

11 AM

12 PM

1 PM Window Watch Patrol—hiss at the
 neighbor's dog

3 PM Shred toilet paper roll

4 PM Nap on kitchen chair...

5 PM

6 PM

6:30 PM Deign to be petted and brushed by Human

8 PM Nap on Human's lap

9 PM

10 PM Chase paper clip around the house

11 PM Tear up and down the hallways to ward
 off evil spirits

12 AM Nap until duty calls again...

KITTY KINGDOMS

What does your feline friend need to feel like King (or Queen) of the World at home? Here's a checklist to make sure Fluffy has nothing but the best.

- ⭘ Basket of expensive toys
- ⭘ Cardboard box
- ⭘ Ball of tinfoil
- ⭘ Window seat for people watching
- ⭘ Big-screen TV
- ⭘ Scratching post
- ⭘ Catnip...every hour on the hour
- ⭘ Lifetime supply of Fancy Feast®
- ⭘ Extensive hunting grounds
- ⭘ Multiple napping spots

THE SUPER DELUXE CAT TREE

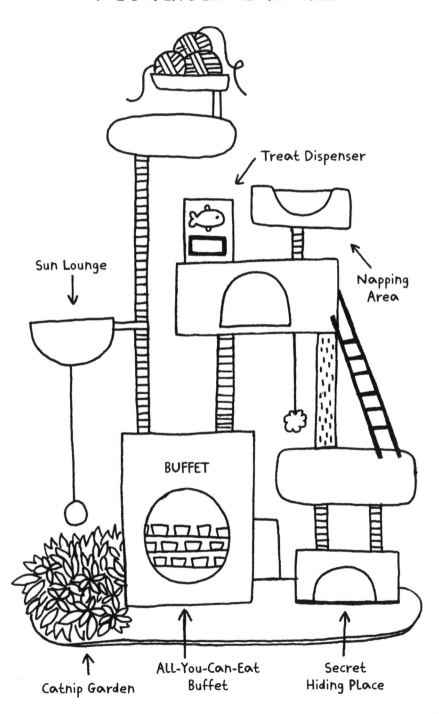

Treat Dispenser

Sun Lounge

Napping Area

BUFFET

Catnip Garden

All-You-Can-Eat Buffet

Secret Hiding Place

Doodle your cat's dream home...and all its accoutrements! Don't forget a nice cozy bed, snacks, and toys!

CATS & DOGS

Cats and dogs... lovers or haters? You decide!

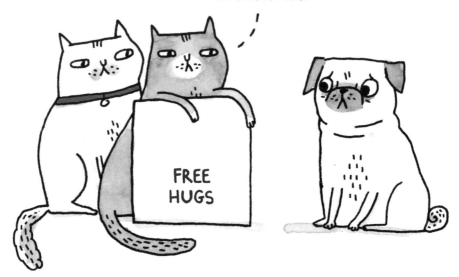

Doodle some canine counterparts with your cat.
Are they friends or foes?

DRAW A PERKY, FLUFFY PERSIAN

1. Draw the ears. Persian cats have smaller, more rounded ears.

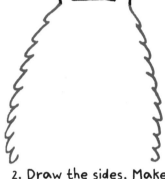

2. Draw the sides. Make them big and fluffy!

3. Add the front legs and paws.

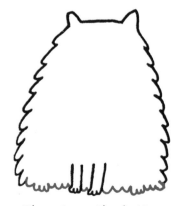

4. Then draw the bottom. (The back paws are in there somewhere!)

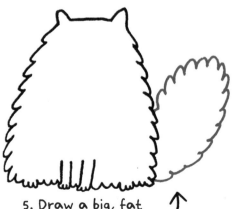

5. Draw a big, fat fluffy tail.

Persian cats have adorably squishy faces.

6. Start by drawing the eyes, and then add a semicircle right below them.

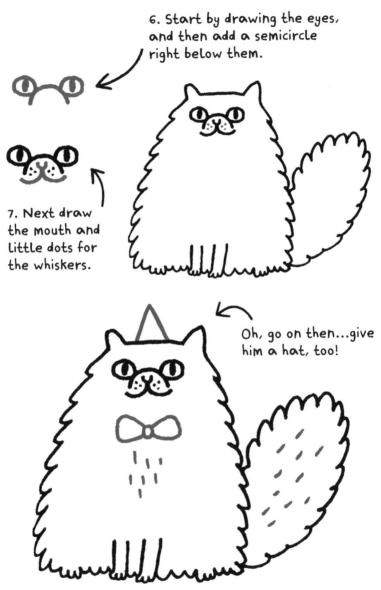

7. Next draw the mouth and little dots for the whiskers.

Oh, go on then...give him a hat, too!

8. Doodle some lines to represent fur— and a little bow tie for extra fanciness!

Doodle your fluffy Persian kitty here!

↓

DRAW A STR-E-E-E-TCHING KITTY

1. Draw the head.

2. Then the two front legs and paws. →

3. Draw two lines curving upwards. Get that kitty butt in the air! ←

Leave a gap for the tail.

4. Next draw the back legs and paws, like this.

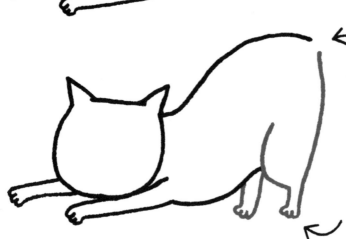

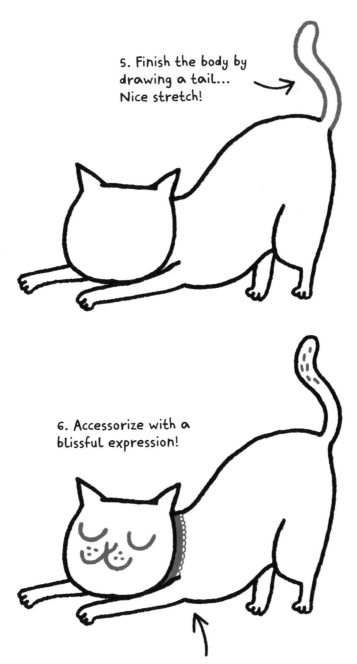

5. Finish the body by drawing a tail... Nice stretch!

6. Accessorize with a blissful expression!

Maybe add a pretty collar too.

Doodle your stretching kitty here!

↓

DRAW A SUPER SPHYNX

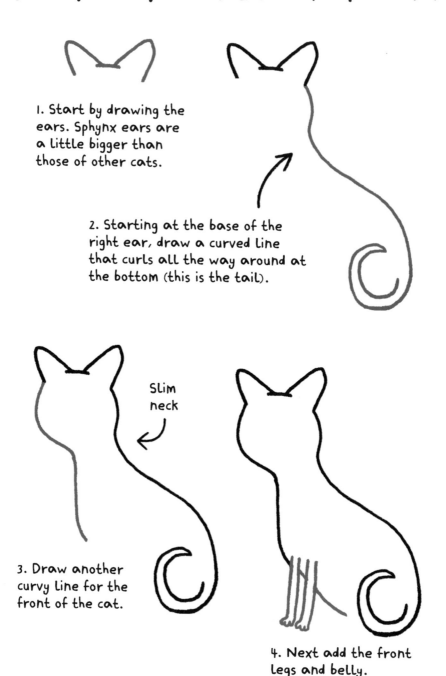

1. Start by drawing the ears. Sphynx ears are a little bigger than those of other cats.

2. Starting at the base of the right ear, draw a curved line that curls all the way around at the bottom (this is the tail).

Slim neck

3. Draw another curvy line for the front of the cat.

4. Next add the front legs and belly.

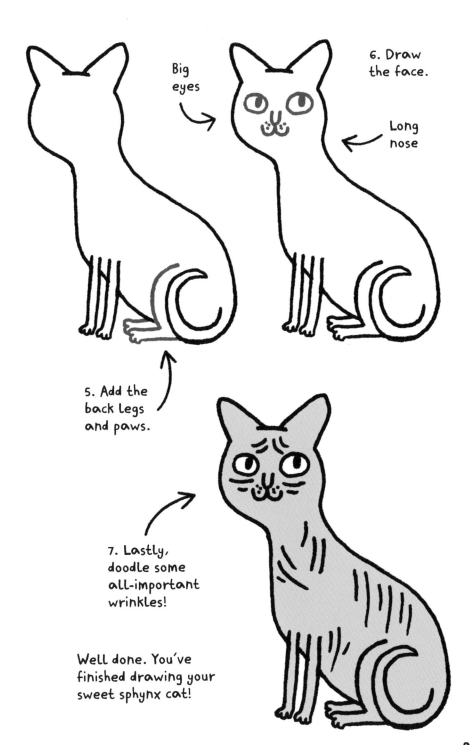

Big eyes

6. Draw the face.

Long nose

5. Add the back legs and paws.

7. Lastly, doodle some all-important wrinkles!

Well done. You've finished drawing your sweet sphynx cat!

Doodle your sphynx cat here!

↓

CATTITUDE

From sweet to sassy, kitties are masters of expressing themselves, be it affection or disdain. Our feline friends have attitude... and they're not afraid to show it!

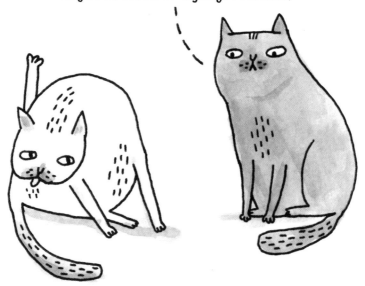

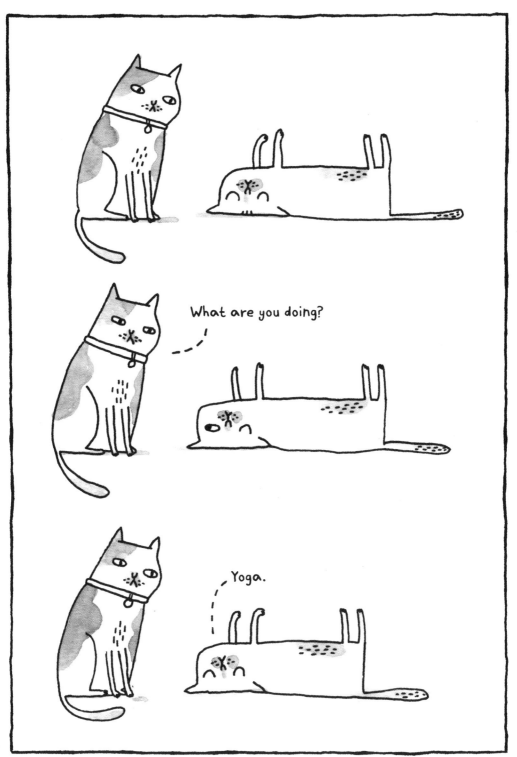

DRAW AN ANTHROPOMORPHIC CAT

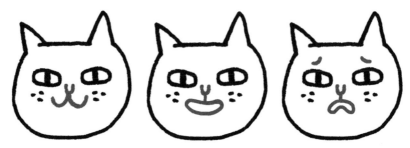

1. Start by drawing the head, just like you would for a "real" cat. Experiment with different facial expressions.

2. Now draw the body, upright like a person (but cuter).

3. Next draw the legs and paws. You might also like to try adding little shoes or booties.

4. Draw a tail if you want to.

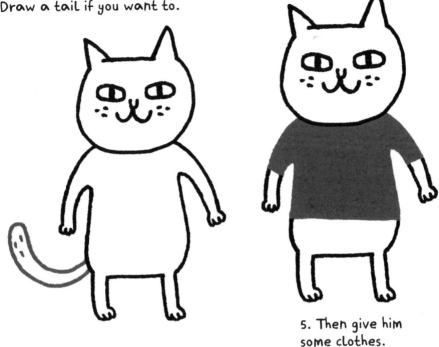

5. Then give him some clothes.

Try out different outfits for your awesome anthropomorphic animal!

Design a T-shirt for your kitty.

Or doodle some cute rosy cheeks!

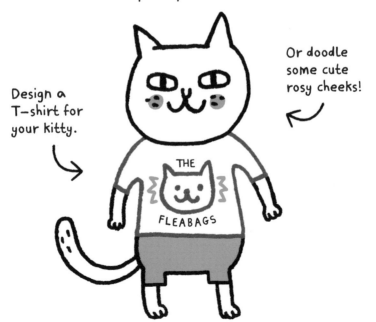

THE
FLEABAGS

Doodle your anthropomorphic kitty here!

↓

CATS IN HATS

Some cats were born to be stars!

Party Hat

Chef's Hat

Fedora

Top Hat

Beanie

Nón Lá

Doodle hats on these kitty heads...

Tam O'Shanter

Beret

Crown

Cowboy Hat

Baseball Cap

Wizard's Hat

CAT-TOIDS

Felines are both universally loved and abhorred—by a small, insignificant, insane segment of the human population—and are one of earth's most fascinating creatures. Here are just a few reasons why...

Fact: Your kitty's nose has a unique ridged pattern—like a human fingerprint!

Fact: Felines spend nearly a third of their waking hours grooming themselves.

Fact: Cats have more than 20 muscles that control their ears.

Fact: A kitty can jump up to five times its length.

Fact: A group of cats is called a "clowder."

Fact: A group of kittens is called a "kindle."

Fact: Cats can make about 100 different sounds.

Fact: Your favorite furry friend may or may not be, but most likely is, plotting your demise.

Fact: Kitties conserve energy by sleeping for an average of 13 to 14 hours a day.

Fact: More than 40 percent of cats are right-pawed or left-pawed...leaving the rest ambidextrous!

Fact: In ancient Egypt, all cats were revered as sacred, helpful, and lucky—something the species has never forgotten...

Fact: With their powerful night vision, cats can see at light levels six times lower than what humans need to see!

Fact: A cat's brain, though small, is more complex than a dog's.

Fact: Kitties only meow to communicate with humans, not with other cats!

FUNKY FUR

You've seen tabby cats and tortoiseshell cats, but have you ever seen a polka-dot cat?

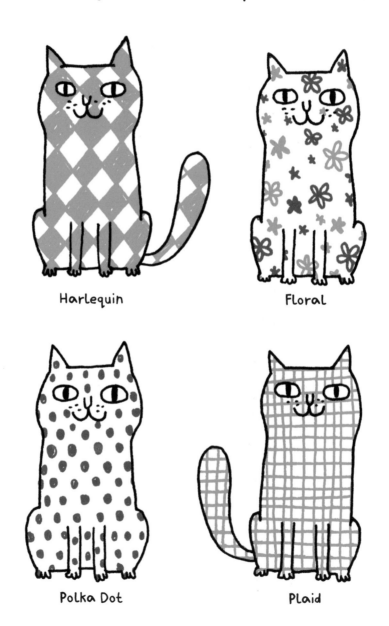

Harlequin

Floral

Polka Dot

Plaid

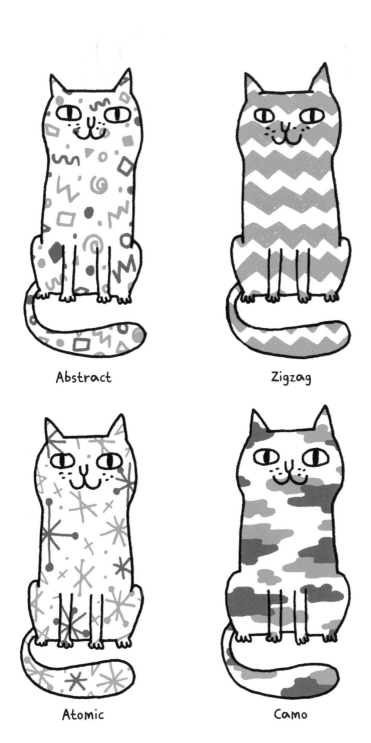

Abstract

Zigzag

Atomic

Camo

Doodle fur-tastic designs onto these pretty kitties. Then add kitty treats, toys, food, etc.

What other patterns can you think of?
Doodle more fabulous fur styles here.

FOOD!

A delicious meal in a can

STINKY TUNA DELIGHT

Cream of MOUSE

Fish 'N' Cheese Surprise

Your cat's favorite

Delicious Treats

YUMMY FISHES

Catnip Drops

Chicken Puffs

TUNA FLAKES

What does your furry friend like to snack on?

Design a special bag of kibble just for your favorite kitty.

'S

KIBBLE

FLAVOR

PLAYTIME!

Here are some favorite cat toys.

Bottle Tops

Pen Lid

What does your cat love to play with?

Hair Band

It's no secret that cats love squeezing into boxes.
Even if they don't really fit!

APPLES

I think I
might be
stuck.

Draw your cat in this box.

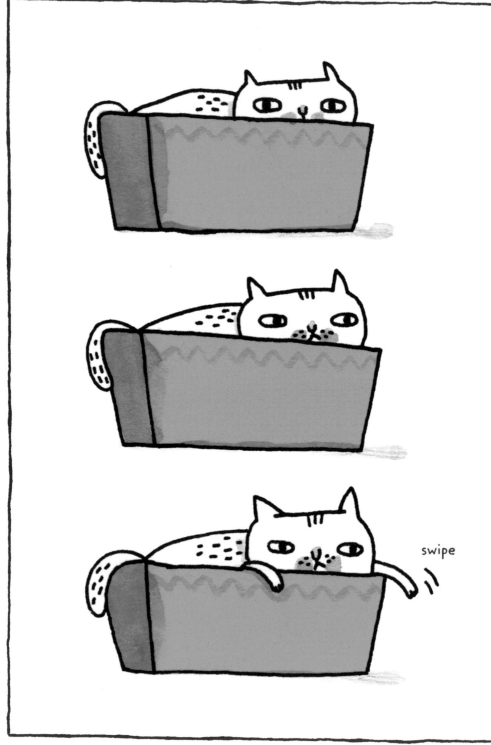

swipe

Design a purr-worthy box for your kitty cat. Make it wild or sophisticated or glamorous!

CATS IN MOTION

Animate your furry friend by drawing an action in two (or more) steps. Try drawing the repeating illustrations on the corners of a stack of papers, or a small notebook. Then flip the pages, and watch the kitty come to life!

Doodle here!

Doodle some moves for your kitty cat here.

KITTIES ON VACATION

These cats are all ready to go on their travels.
Where do they think they are going?

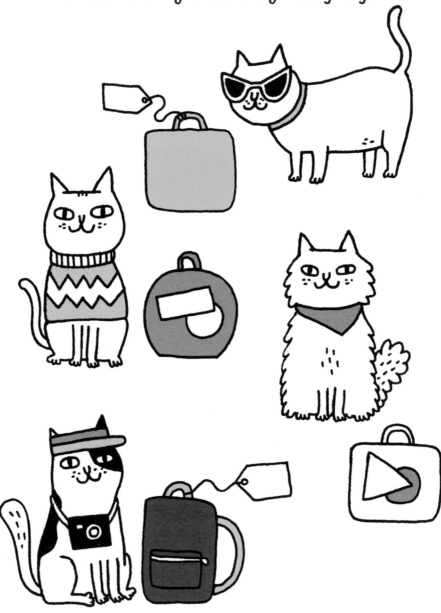

Who else is having fun on the Kitty Koaster?

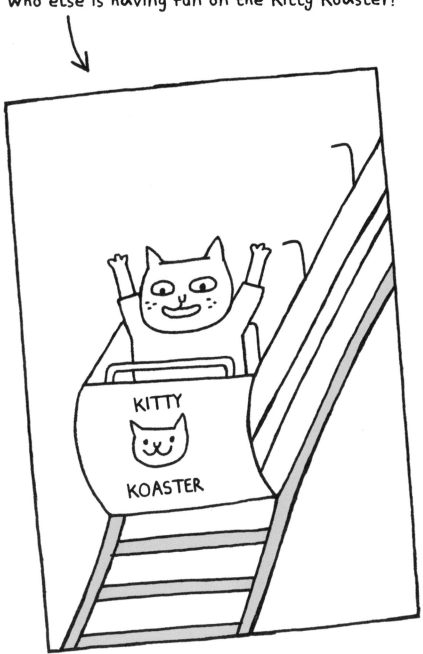

Draw another kitty on the sailboat.

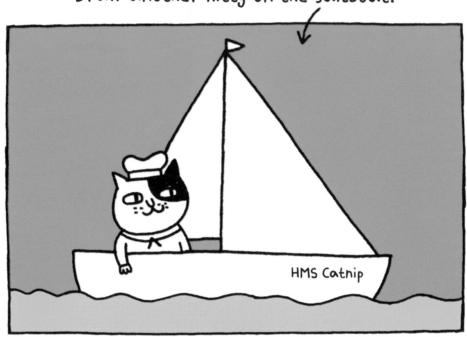

HMS Catnip

Who else is at the kitty café?

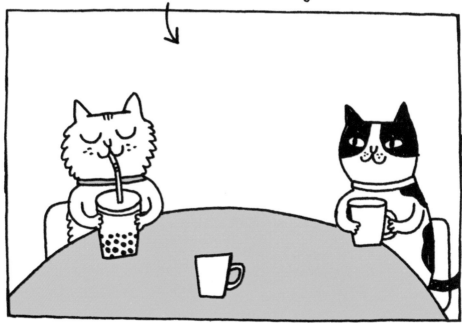

Draw another cool cat hitting the slopes.

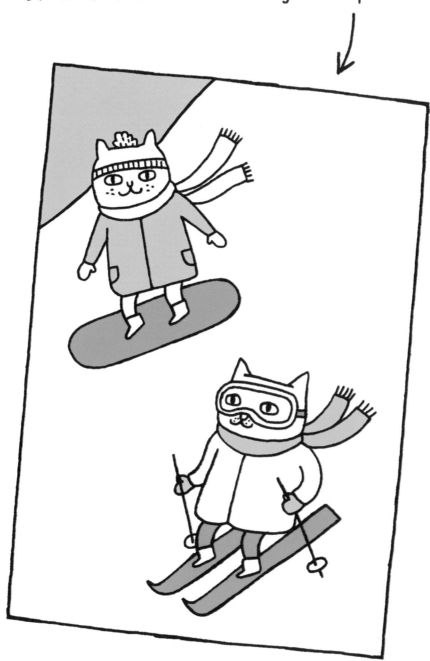

Where are your favorite vacation spots?
Doodle your favorite furry feline in your
dream destinations!

Design a postcard from your amazing
vacation together!

GREETINGS FROM

DOODLE DIARY

Use these pages to doodle all your favorite kitties—real or imaginary—doing all their favorite things.

ABOUT THE ILLUSTRATOR

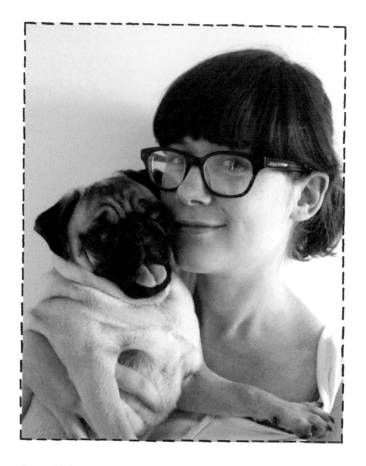

Gemma Correll is a cartoonist, writer, illustrator, and all-around small person. She is the author of *A Cat's Life*, *A Pug's Guide to Etiquette*, and *It's a Punderful Life*, among others. Her illustration clients include Hallmark, *The New York Times*, Oxford University Press, Knock Knock, Chronicle Books, and *The Observer*.
Visit www.gemmacorrell.com to see more of Gemma's work.